NATURE
ABUNDANT

AFFIRM YOUR BEST LIFE THROUGH NATURE

GREGORY JOSEPH BOROWSKI

Acknowledgements

I would like to express my gratitude to Clarence Atkins and Dr. Ben Carlsen who always encourage me to aim higher.

Follow us on social media!

 Nature Abundant #Nature_Abundant

This edition published by Flying Page Publishing
Edited by Grace Anne Borowski

ISBN: 978-1-63848-215-4
Library of Congress Control Number: 2021906476

Preface

Nature finds a way of finding us. The grass growing between a sidewalk crack, the raindrops on a window, a lady bug on the front door; it's everywhere we look. Perhaps nature is constantly telling us to notice it. Nudging us to engage in a state of mindful consciousness. Mindfulness is the human mental ability to focus on the present moment, shift away from incessant preoccupations and calmly accept and appreciate our bigger picture in life.

Here's where my story begins. I've had a dog for six years now and with that comes the responsibility to walk him multiple times a day. Living in Florida, and now North Georgia, we have walked miles and miles amongst some of the most spectacular landscapes around. Nature always being available, my dog was having the time of his life, yet I was somewhere else. My mind was not just wandering, it was spinning out of control with self-created irritations, worries, anxieties and regrets. I was unhealthy. One day I shut down. Along a wide river, I sat down on a bench and collapsed into my lap. After some time had passed, I looked up and saw my dog peacefully watching the water. I joined him, focusing on the ripples glistening in the sunlight. It was beautiful. I was being mindful and it felt really good.

In tune with my senses, closely observing the sights, sounds and smells in nature, I discovered a unique state of awareness that made mindfulness such a simple and powerful tool for me. From my own impressions and research of nature symbolism throughout civilization, I started connecting elements of nature with positive qualities and life enhancing concepts. Affirmations further reinforced my commitment to shift my thinking and to begin shaping a promising future. I hope sharing my experiences and insights can encourage you to move into the present moment too. It's the most wonderful place to be.

Index

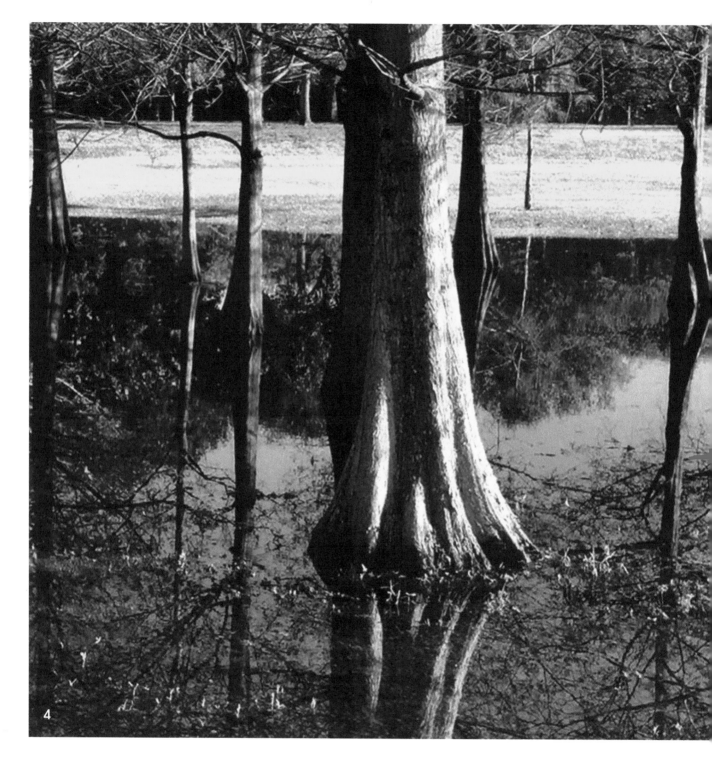

TREES
EMBODY
STRENGTH

Strength is a force. A force of nature in a sense. It is the inexplicable ability to bear and overcome physical, emotional and spiritual challenges. The tree can symbolize that force with its roots firmly grounded in the earth and its branches rising to the ethereal heavens. The solid core of its trunk can represent the strength of your inner beliefs or physical wellness, the outreaching branches for your advancement and the leaves for your amazing achievements.

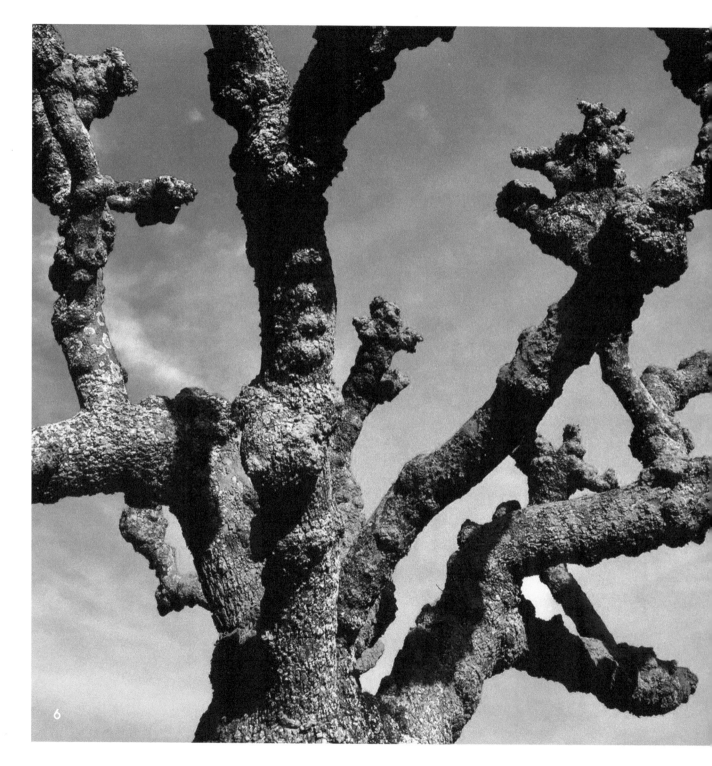

AFFIRMATIONS

I AM STRONG ENOUGH TO GET THROUGH THIS.

I AM GROWING IN PHYSICAL STRENGTH EACH DAY.

I TRUST IN THE STRENGTH OF THE UNIVERSE.

I STAND TALL AND STRONG IN THE FACE OF CHALLENGES.

ALL THE CELLS IN MY BODY KEEP GETTING STRONGER.

I GO OUT ON A LIMB, AND I KNOW IT'S SAFE TO BE THERE.

I STAND STRONG, TALL AND PROUD TO BE ME.

I HAVE THE POWER IN ME TO STAY STRONG AND PROSPER.

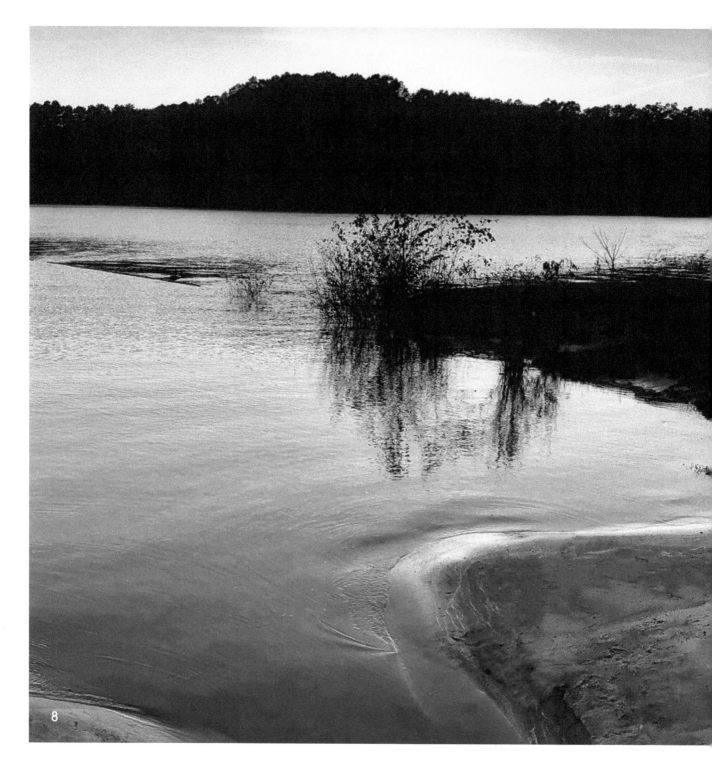

WATER
REPRESENTS
FLOW

Flow is movement. A current that is steady, continuous and always advancing. It is associated with attracting abundance such as money, love, freedom, relationships or happiness and has an endless source available to all. Water flows everywhere: brooks, rivers, lakes, oceans, rain and in 65% of your body. Virtually accounting for over two thirds of the Earth's surface, its vast depth can't help but be of profound importance to life itself. Water is boundless and ready to outpour unlimited possibilities and positive outcomes.

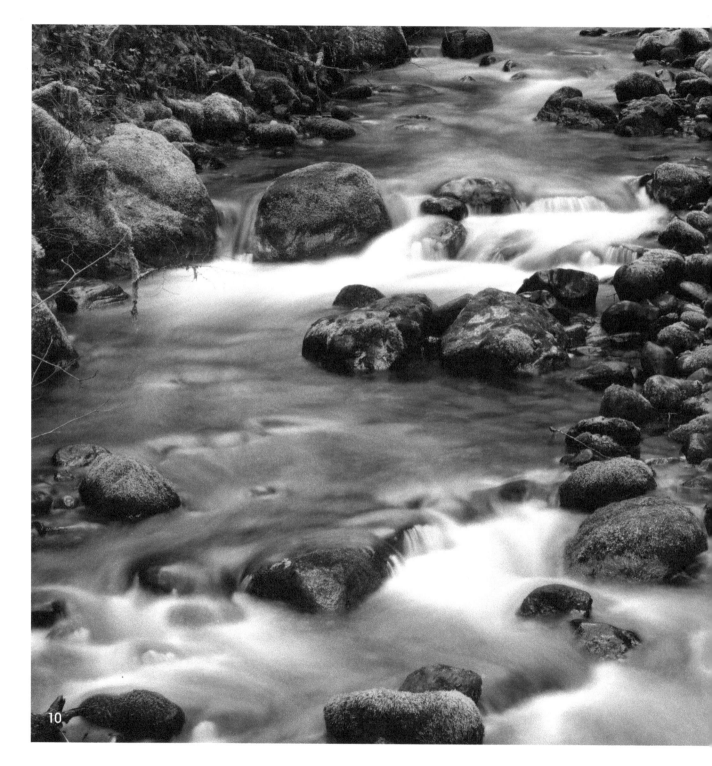

AFFIRMATIONS

MY WORK FLOWS JOYOUSLY AND EFFORTLESSLY.

MONEY FLOWS TO ME FROM EXPECTED AND UNEXPECTED SOURCES.

I ALLOW WONDERFUL RELATIONSHIPS TO FLOW INTO MY LIFE.

MY JOB OPPORTUNITIES ARE OVERFLOWING.

HEALTH, ENERGY AND WELL-BEING FLOW INTO MY LIFE RIGHT NOW.

I LET GO, AND GO WITH THE FLOW.

I GUSH WITH CREATIVITY.

I AM IN THE FLOW OF MY HAPPIEST LIFE.

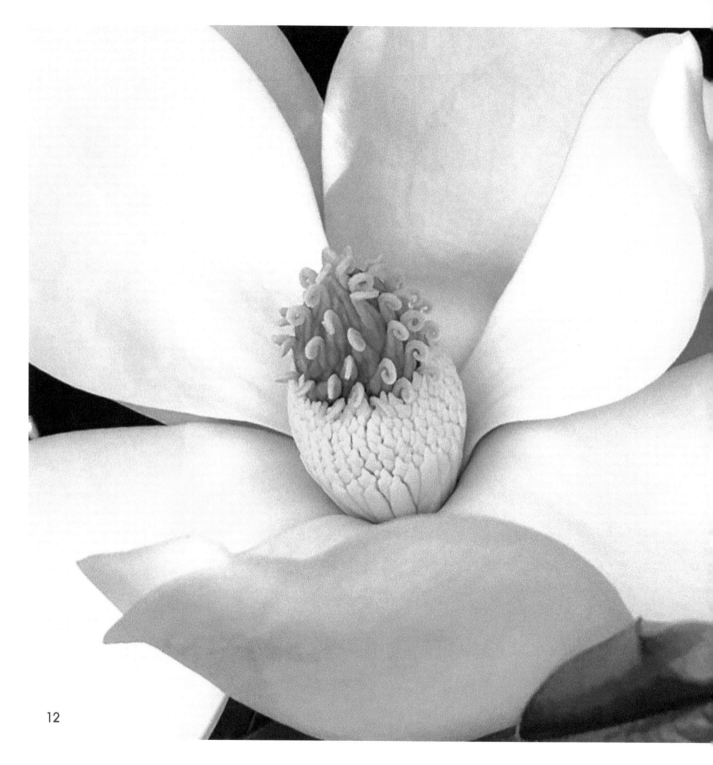

FLOWERS
EMBODY
BEAUTY

Beauty is everywhere. If you don't notice, it will eventually find you in the form of a flower. Qualities like color, symmetry, fragrance, luster and aliveness make it hard not to notice the beauty of a flower. They are stimulating and soothing at the same time. Often breathtaking. A flower can remind you of the perfection and lovliness of your divine origin. The more beauty you perceive inside and out, the more you radiate outward, sharing invaluable blessings with others.

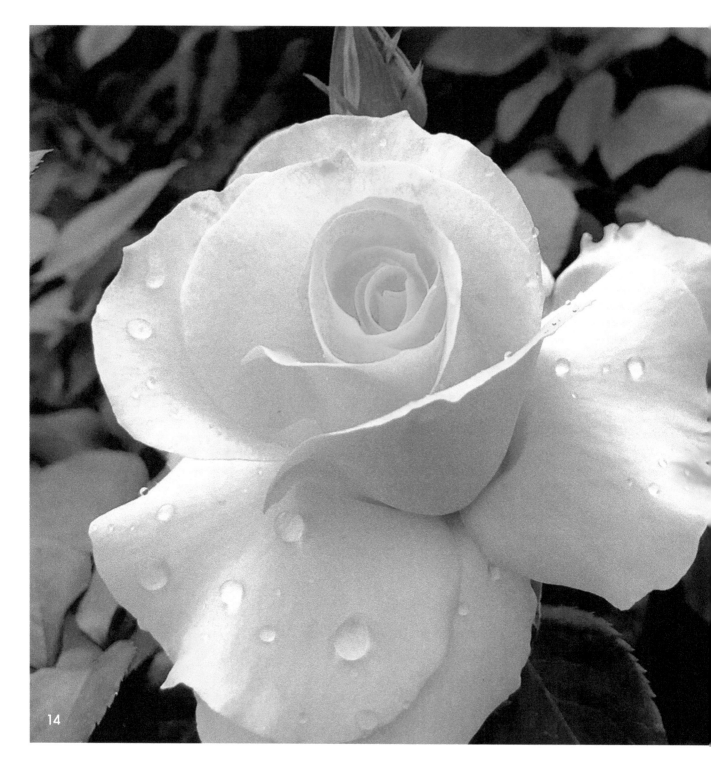

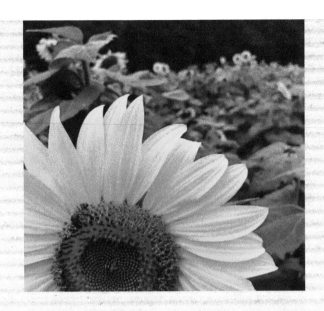

AFFIRMATIONS

I SEE THE TRUE BEAUTY IN EVERYTHING.

I AM BEAUTIFUL, INSIDE AND OUT.

MY LIFE GROWS MORE BEAUTIFUL EACH DAY.

SOMETHING BEAUTIFUL IS OPENING UP TO ME RIGHT NOW.

I AM GRATEFUL FOR THE BEAUTY OF NATURE.

LIFE IS A BEAUTIFUL, GRAND ADVENTURE.

I DESERVE AND APPRECIATE MY BEAUTIFUL THINGS.

MY CREATIVITY IS BOUNDLESS AND BEAUTIFUL.

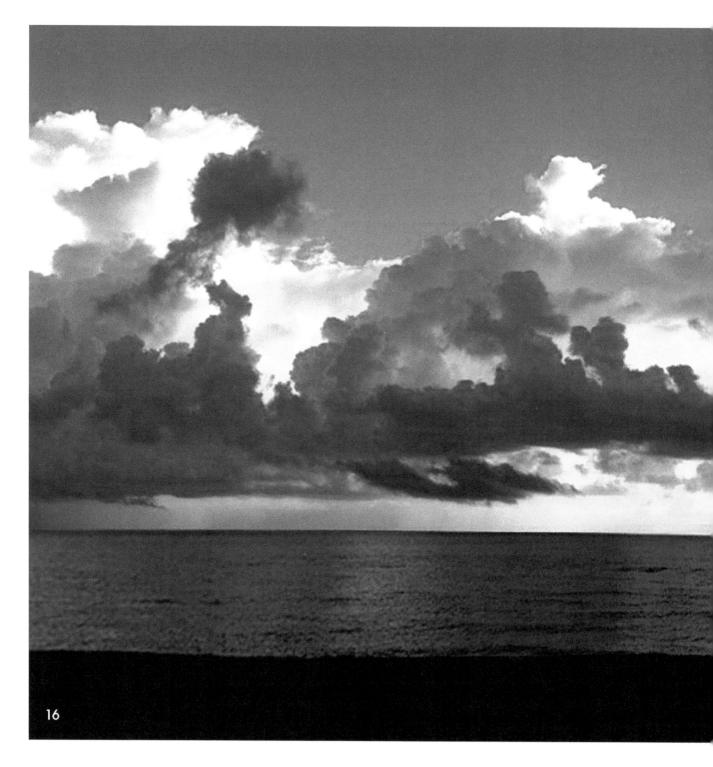

CLOUDS
SYMBOLIZE
DREAMS

Clouds gently maneuver, shape and compose. Much like your dreams and desires, they prepare to transform by softly maintaining a quality of peace and calm. When your dreams are not manifesting fast enough, gaze upon the clouds. They have no timeline or agenda. They can represent the union of preparedness and patience. Release, and allow your dreams to float upward to a higher power. Trust, and expect amazing things will happen.

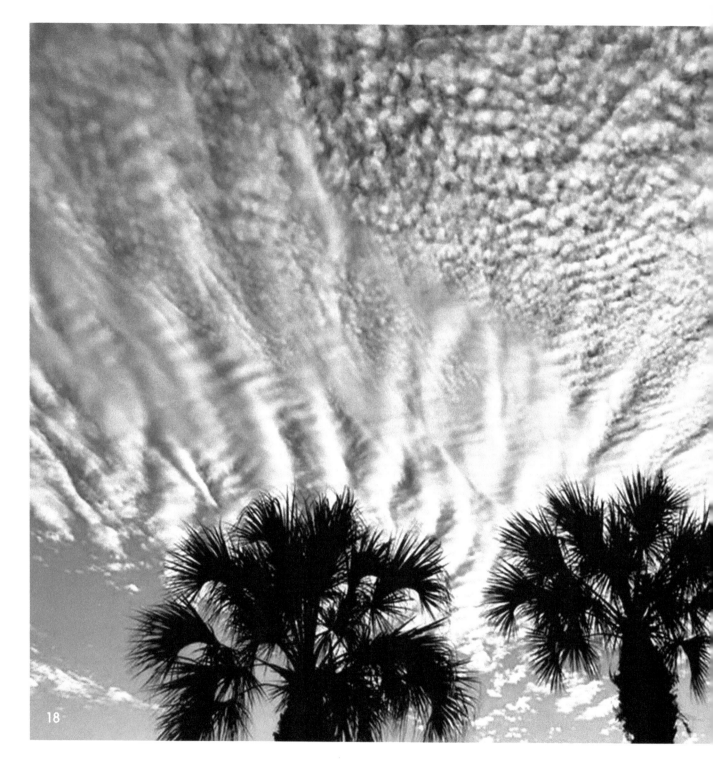

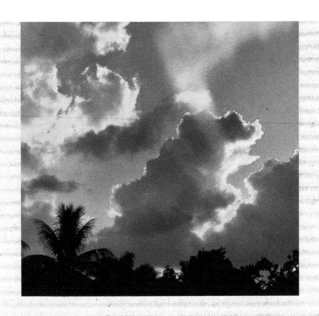

AFFIRMATIONS

I ALLOW MYSELF TO DREAM BIG.

I MOVE CONFIDENTLY TOWARD MY ULTIMATE DREAMS.

MY DREAM JOB IS ALREADY HERE.

I LOOK UP AND NEVER LET GO OF MY DREAMS.

MY DREAMS ARE BIG, BOLD, BEAUTIFUL AND REAL.

I DREAM HIGHER THAN THE CLOUDS TO CREATE MY NEW REALITY.

MY FUTURE SUCCESS STARTS WITH A DREAM.

I AM READY TO TAKE ACTION TO ACHIEVE MY DREAMS.

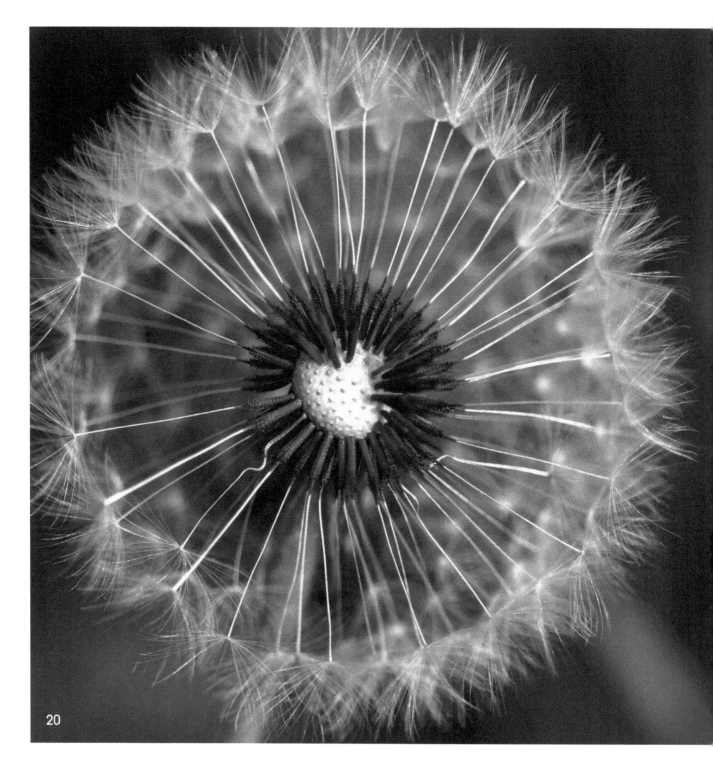

SEEDS
REPRESENT
POTENTIAL

Potential is in all of us. It's our birthright and perhaps even our responsibility to uncover our potential throughout life's journey. A seed is minuscule, yet can grow into a tree ten stories high that propagates yearly by producing thousands of more seeds. The seeds to your highest potential are positive thoughts. As you plant and nurture more positive thoughts, the more opportunities emerge to live joyfully, create meaning and ever evolve toward your authentic nature.

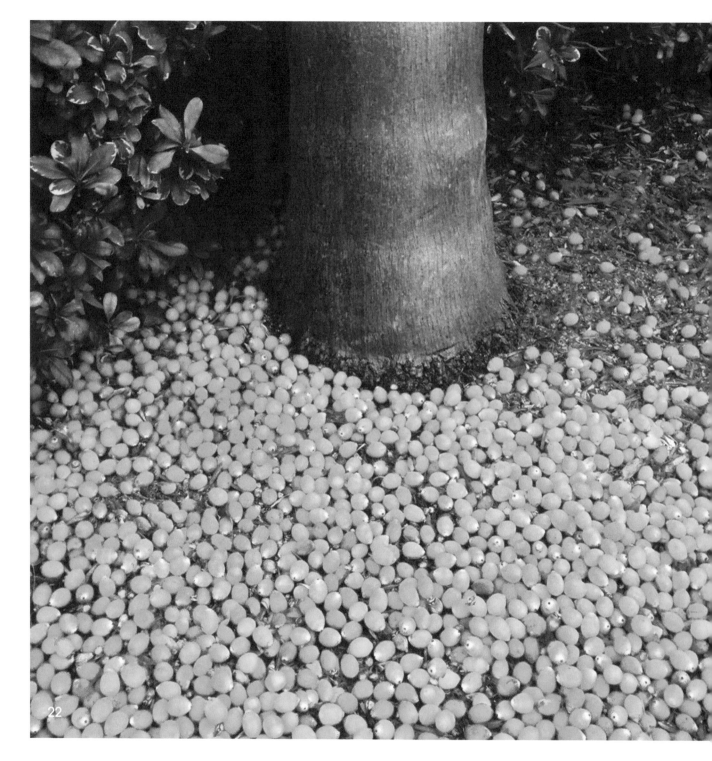

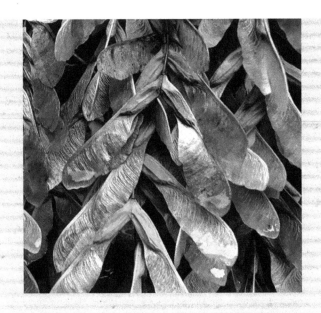

AFFIRMATIONS

I AM READY TO PLANT MORE SEEDS.

I HAVE UNLIMITED POTENTIAL.

PLANTING POSITIVE THOUGHTS REAP THE HIGHEST REWARDS.

I NOW UNLOCK MY HIGHEST POTENTIAL.

THE POTENTIAL FOR ABUNDANCE IS ALREADY IN ME.

I AM CAPABLE OF BEING MY BEST SELF.

SEED MONEY COMES TO ME.

I AM READY TO STEP INTO MY HIGHEST GOOD.

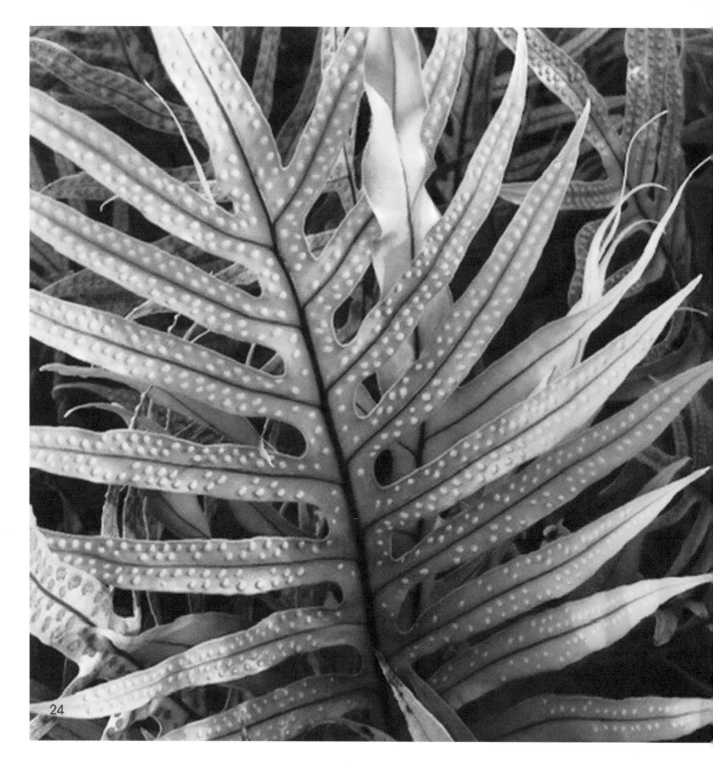

LEAVES
SYMBOLIZE
GROWTH

After the seed and germination stages, growth is the third stage of a plant's life cycle. It's the stage where things really start to happen. Leaves grow, and photosynthesis provides the sugars to feed and strengthen its stem and roots. You have a growth stage too. A time when an innate desire to change, move forward or seek a higher purpose starts to become evident. Leaves represent the motivation to take actions that propel you toward ultimate success.

AFFIRMATIONS

I AM READY TO TAKE RISKS AND GROW.

I GROW IN LEAPS AND BOUNDS.

MY BANK ACCOUNT GROWS LARGER AND LARGER.

IT IS NEVER TOO LATE FOR ME TO GROW.

I AM IN CONSTANT PURSUIT OF IMPROVEMENT.

I GROW AT THE PERFECT PACE FOR ME.

I ATTRACT A GROWING GROUP OF SUPPORTIVE FRIENDS.

I NOW PUT PERSONAL GROWTH FIRST.

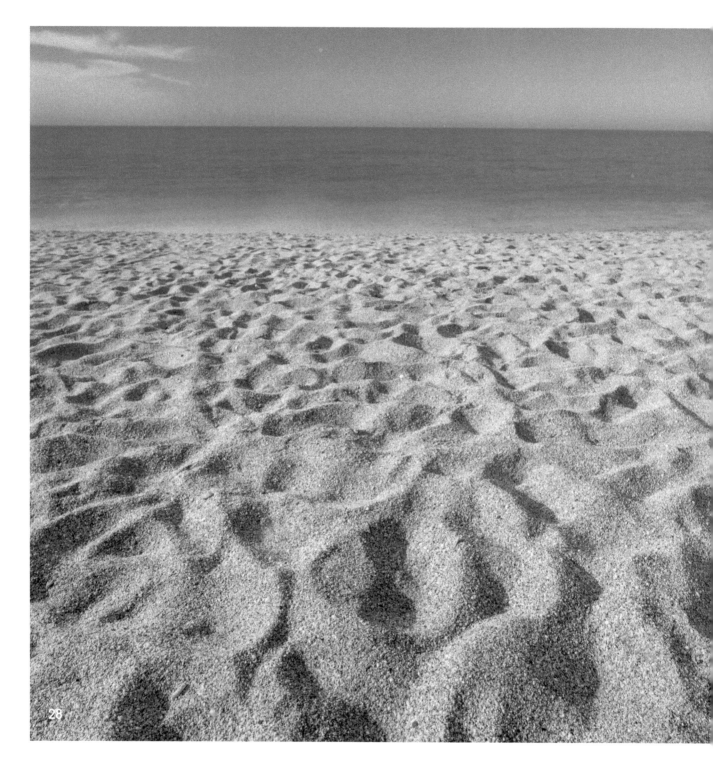

SAND
REPRESENTS
MULTITUDE

Run a handful of sand through your fingers. You can't count the thousands of falling granules. Now imagine the number beneath your bare feet, along the entire beach or within the Sahara Desert. The multitude of sand granules can remind you that the universe has unlimited abundance that can never run out. Sand is your cue that there are infinite possibilities, ideas and solutions to any challenge. It's time to break down barriers and recognize that your one universal source is there to provide.

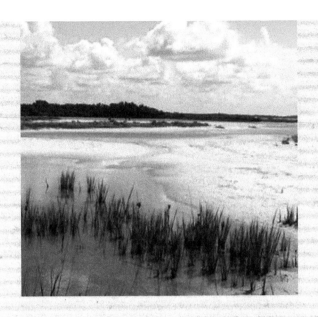

AFFIRMATIONS

MY IMAGINATION HAS NO LIMITS.

POSITIVE OUTCOMES ARE NUMEROUS AND NEVER-ENDING.

I AM OPEN TO A MULTITUDE OF TRAVEL EXPERIENCES.

ANOTHER SOLUTION IS ALWAYS WAITING TO BE FOUND.

MY POSSIBILITIES ARE ENDLESS.

I HAVE A MULTITUDE OF OPPORTUNITIES FOR LOVE, PEACE AND HAPPINESS.

I HAVE A MULTITUDE OF CHOICES FOR WHAT I CAN THINK.

ONE OR A MILLION, IT'S UP TO ME.

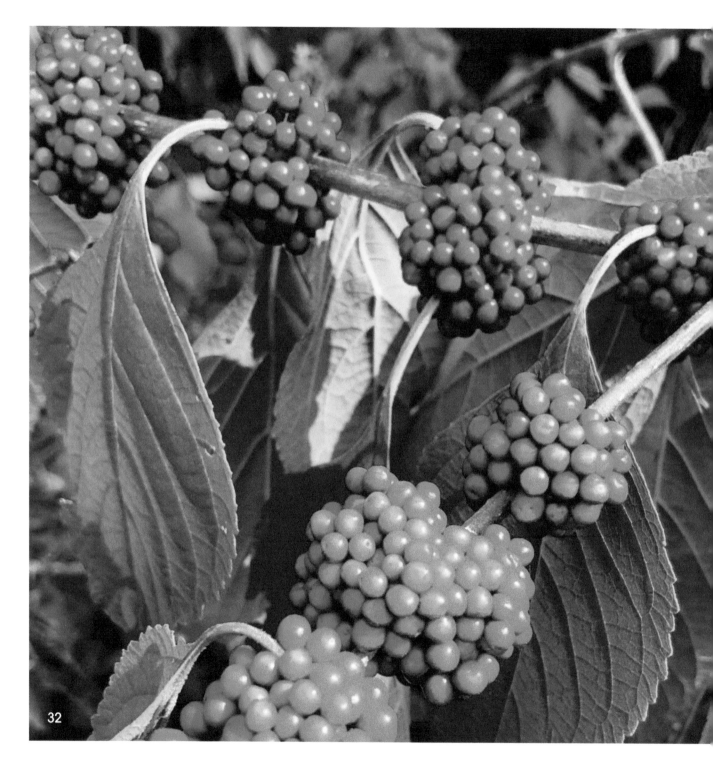

BERRIES
EMBODY
RESULTS

Berries are extraordinary. Beautiful fruits of nature's labor. They can symbolize the positive results and benefits of your hard work. Tasty, plentiful and organized; your planning paid off. Berries cling to their source and don't let go. Determination, persistence and steadfastness bear optimal results. Whether big or small, recognize and be grateful you got this far. Savor your accomplishments. Take a moment to feel remarkable. Be victorious.

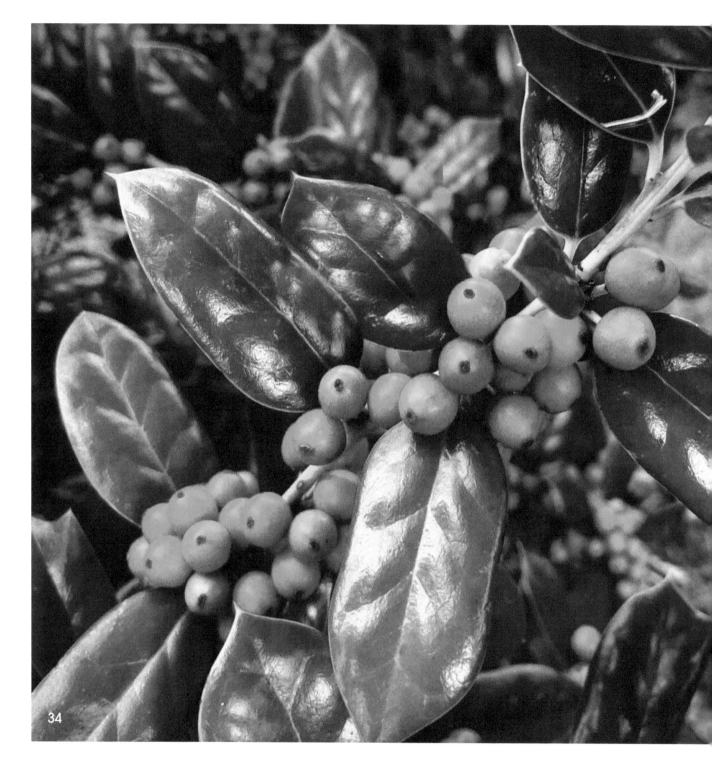

AFFIRMATIONS

I AM READY TO SEE RESULTS.

THE FRUITS OF MY LABOR PRODUCE RESULTS BEYOND EXPECTATION.

AS I RELEASE MY DESIRES THE RESULTS WILL COME.

I EXPECT MIRACLES ALWAYS.

I ACHIEVE SUCCESSFUL RESULTS WITH EVERYTHING I DO.

GREAT RESULTS POP UP FROM EVERYWHERE.

I ALWAYS SEE POSITIVE RESULTS BEFORE THEY EVEN HAPPEN.

I DO THE WORK SO I GET RESULTS.

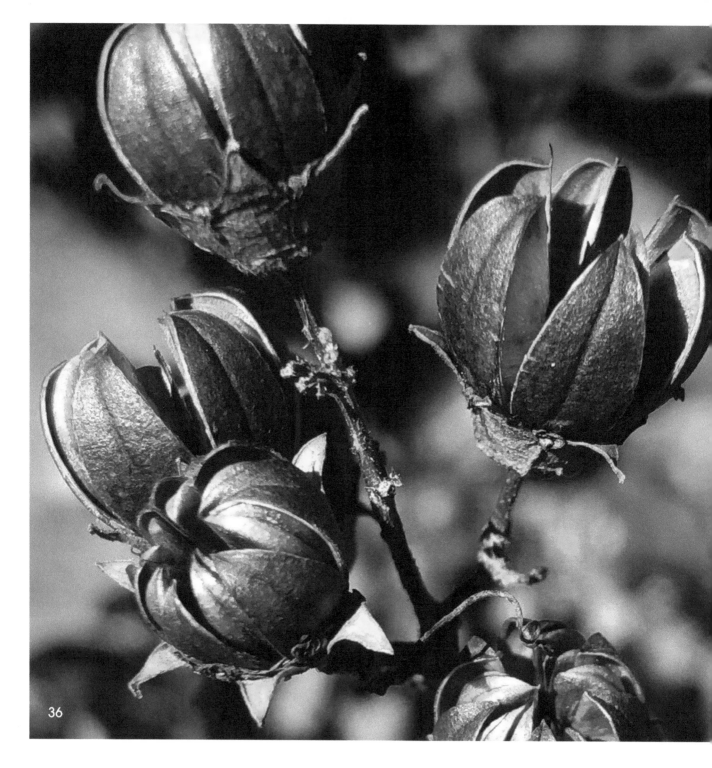

PODS
SYMBOLIZE
SAFETY

Pods represent a sanctuary of safety, a "safe place" if you will. A refuge from physical or emotional harm. A quiet space where you can go to assess and recalibrate what you need to feel secure and stress-free. Not a place to hide, but a haven where you can get in touch with your true self and confront your fears without judgment or distractions. It's in this space where you can connect with a higher power or delve deep inside yourself for insight. Soon the pod will open, ready for you to emerge and take the necessary action.

AFFIRMATIONS

IT IS SAFE FOR ME TO EXPRESS MY FEELINGS.

I FEEL SAFE, SECURE AND LOVED.

THE UNIVERSE ALWAYS PROVIDES MY SAFETY NET.

IT IS SAFE TO BE EXACTLY WHO I AM.

THE WORLD IS A SAFE PLACE.

MY HOME AND FAMILY ARE SAFE AND PROTECTED.

I AM SAFE TO TRUST MORE.

MY LIVING ENVIRONMENT IS A SAFE SPACE.

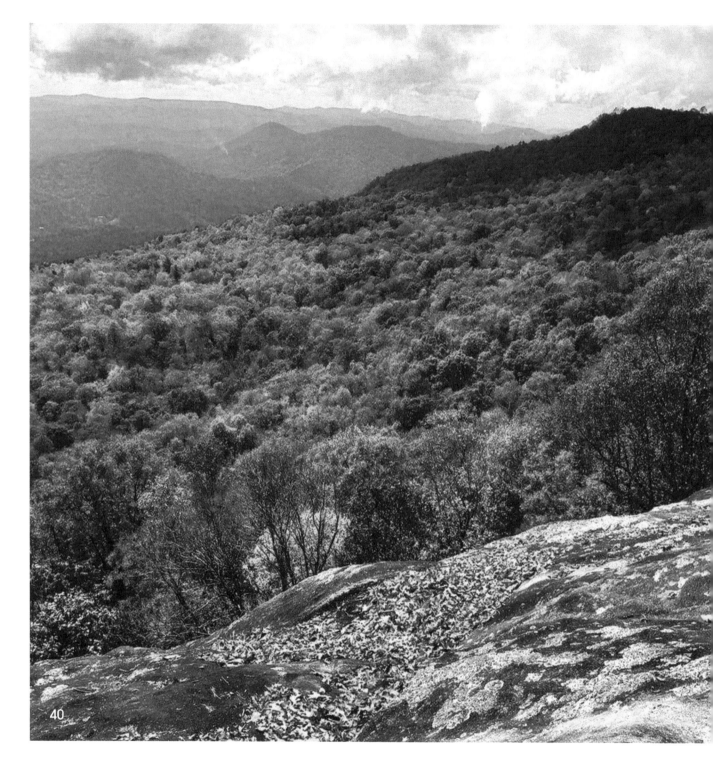

HILLS
EMBODY
GOALS

Climbing over hills or winding through them can represent overcoming obstacles and moving toward your goals. Hills symbolize progress. The undertaking is right in front of you, and you are willing and ready to conquer it. The higher you scale a hill the closer you get to attaining your goal and feeling the amazing sense of accomplishment. Don't look back at regrets or self-doubt. Keep your mental and spiritual state climbing, staying on the path of improvement. Set your goals high, and don't stop until you get there.

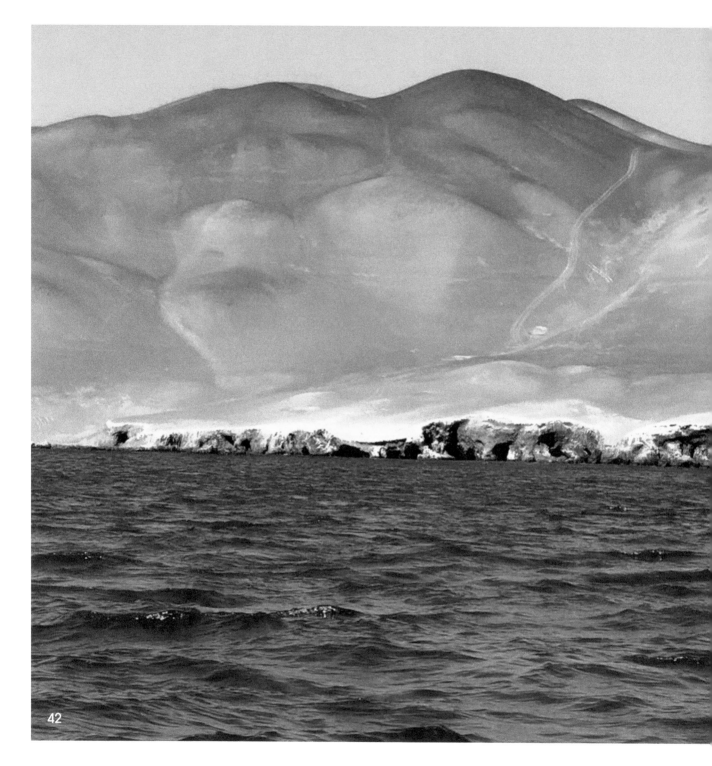

AFFIRMATIONS

I AM BRAVE ENOUGH TO CLIMB ANYTHING.

I AM WILLING TO TAKE THE STEPS TOWARD REACHING MY GOALS.

I RELEASE ALL OBSTACLES TO MY GREATEST GOOD.

MY GOALS ARE WORTH ACHIEVING.

I HAVE CLARITY AND DIRECTION TO FULFILL MY GOALS.

I ATTRACT THE PERFECT TIMING TO ACHIEVE MY GOALS.

ALL MY GOALS ARE CLEARLY DEFINED AND MET.

I'M ON TOP OF THE WORLD.

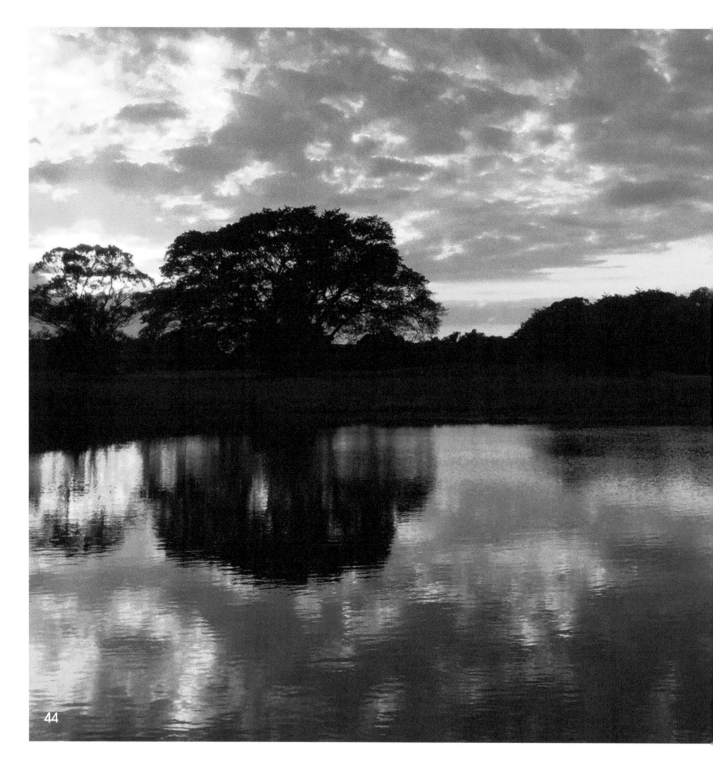

SUNRISE
REPRESENTS
REBIRTH

A sunrise can provide a clean slate for whatever you were thinking or experiencing yesterday, the week before, or for that matter, your entire past. Awaken to the guiding light for a new beginning, with permission to change. Take a deep breath, and start anew by forgiving the past and defining what would make your next minute amazing. Expand outward, and picture your incredible day, week, year and even your lifetime. The quiet, still and undistracted moment of a sunrise opens up the space to formulate new ideas and desires. Imagine all the incredible outcomes.

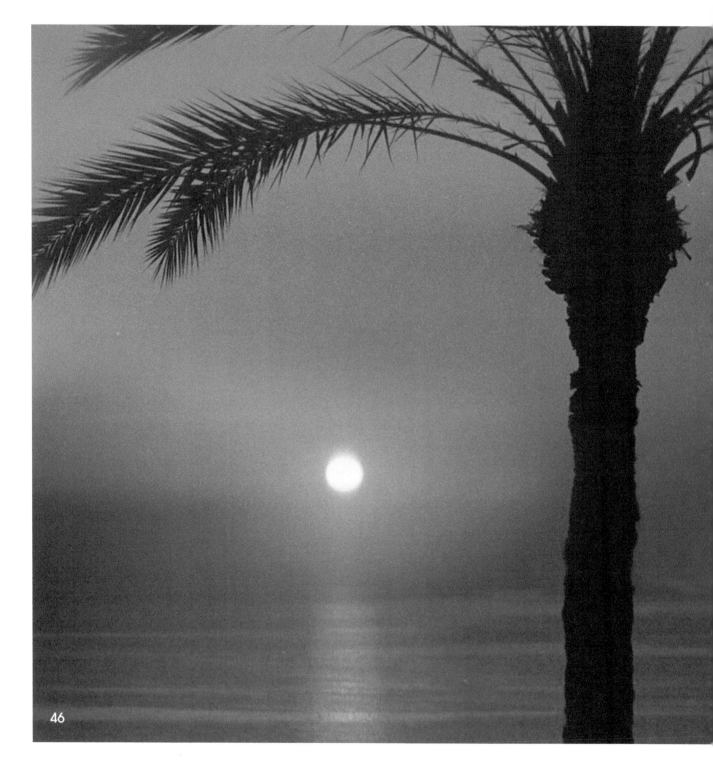

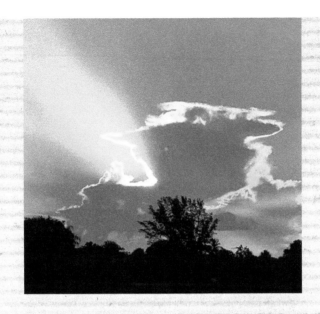

AFFIRMATIONS

I BEGIN MY DAY ON THE SUNNY SIDE OF LIFE.

THE SUNRISE FREES ME TO START OVER.

I AM FREE FROM THE PAST AND FEEL REBORN.

EVERY DAY I IMPROVE IN EVERY WAY.

I AM REFRESHED, RENEWED AND READY TO START MY DAY.

MY TRANSFORMED LIFE BEGINS NOW.

IT IS SAFE FOR ME TO LET GO OF THE PAST.

TODAY THE NEW ME IS AWAKENING.

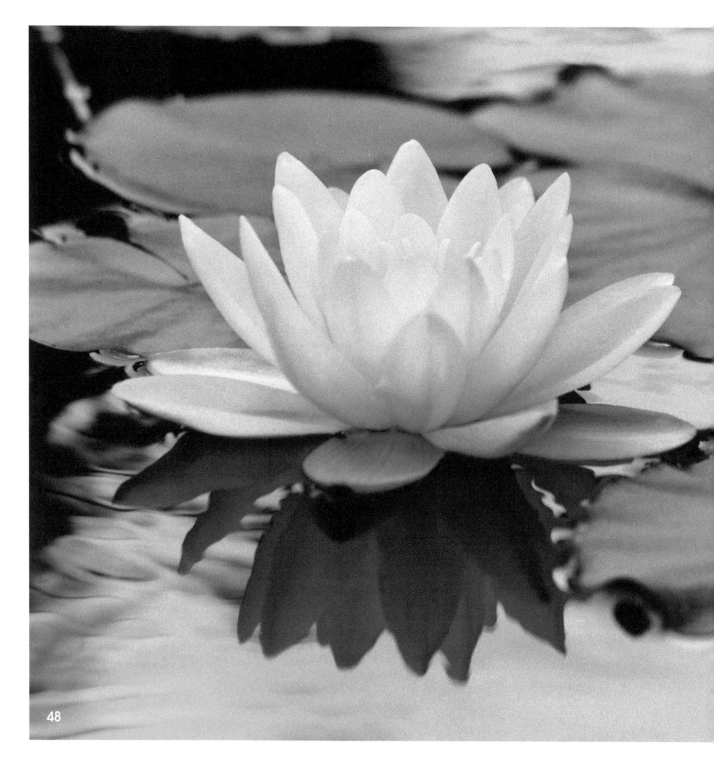

LOTUS
SYMBOLIZES
ENLIGHTENMENT

The lotus can represent how we attain self-realization through spiritual practice and progress. It has a special place in many of the world's religious dogmas. Most notably, the lotus is present in the seven Hindu chakras with its crown chakra having a thousand petals. These petals represent the layers of life's victories and challenges which we all grow from. Admire the lotus as a symbol of oneness, synchronicity, spiritual strength and enthusiastic awakening. We all can be a higher version of ourselves and reach our ultimate purpose.

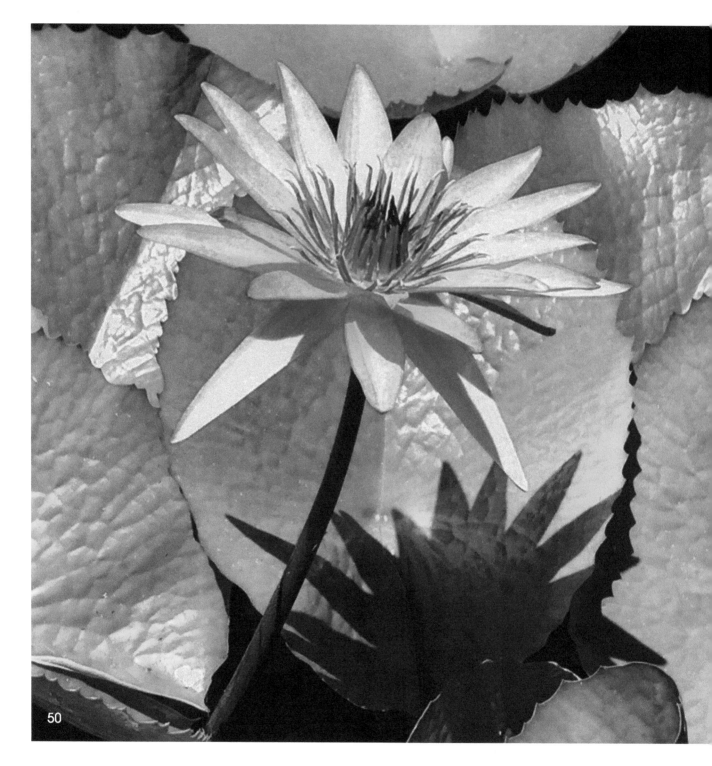

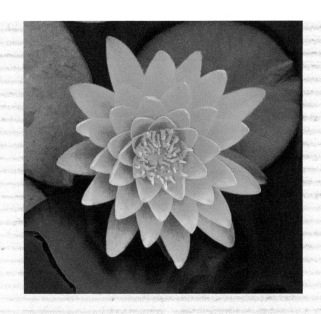

AFFIRMATIONS

I FLOAT IN THE PRESENCE OF COMPLETE ENLIGHTENMENT.

I RADIATE FEARLESS CONFIDENCE.

I AM ENLIGHTENED TO THE TRUTH OF WHO I AM.

I AM HEALTHY, WEALTHY AND WISE.

ENLIGHTENMENT IS MY NATURAL STATE OF BEING.

I AM PURE LOVE, PEACE AND JOY.

MY CARING AND SUPPORTIVE FRIENDS ENLIGHTEN ME.

I ILLUMINATE THE WORLD AROUND ME.

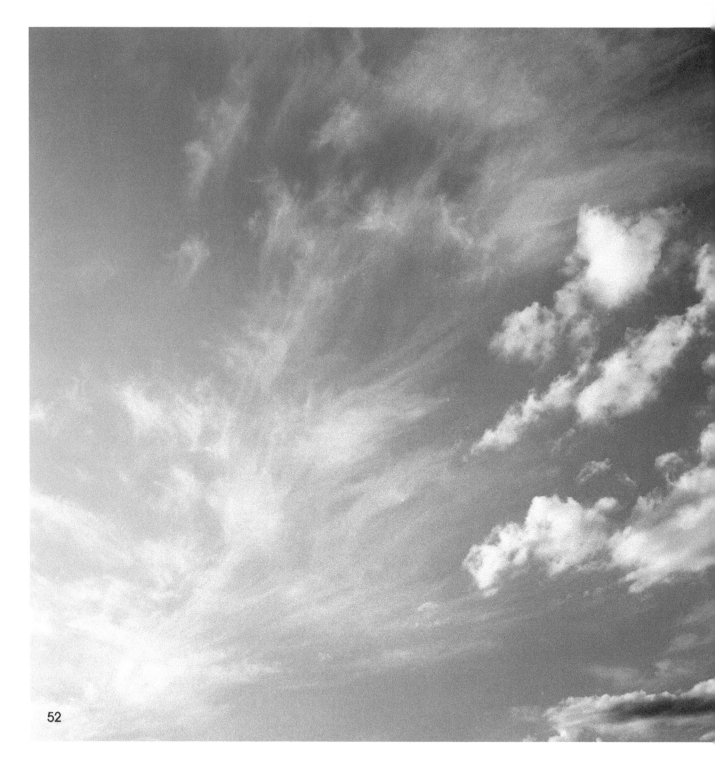

SKY
REPRESENTS
LIMITLESS

The sky is not the limit. Virtually limitless, the sky expands past the stratosphere, beyond the moon, sun, stars and galaxies. Look up to the sky and recognize your never-ending possibilities. The symbolic nature of the sky can represent inspiration, clarity, freedom and optimism. A reminder that the infinite universe is cooperative and conspires to reach your highest potential. All things are possible. Dare to dream, trust boundlessly and watch your spirit fly.

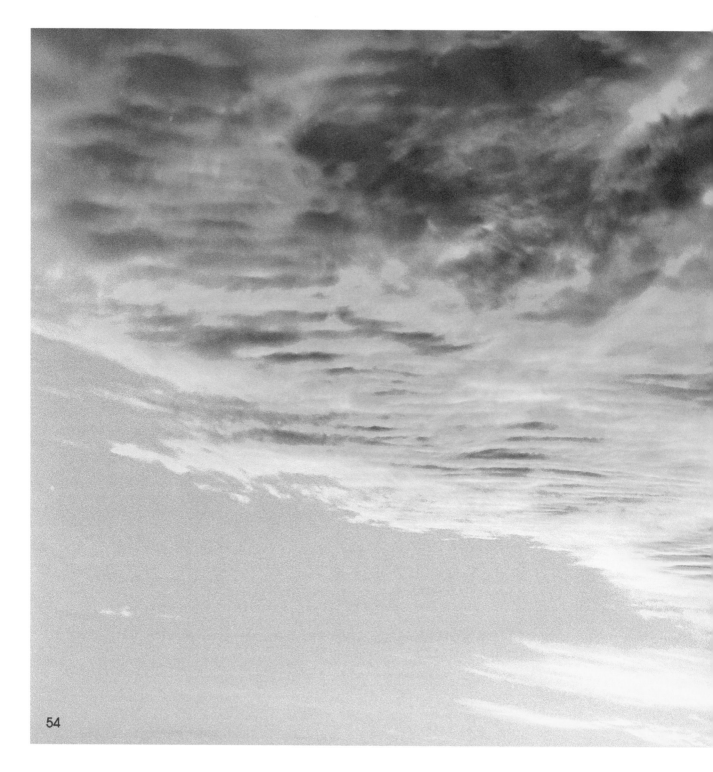

AFFIRMATIONS

MY CREATIVE MIND KNOWS NO LIMITS.

I AM READY TO RECEIVE A CONSTANT AND LIMITLESS SUPPLY OF MONEY.

I AM LIMITLESS IN WHAT I CAN ACCOMPLISH.

I AM GRATEFUL FOR THE LIMITLESS ABUNDANCE IN MY LIFE.

I AM OPEN TO UNLIMITED OPPORTUNITIES.

I AM LIMITLESS IN THE LOVE AND TALENT I HAVE TO OFFER.

I RELEASE MYSELF FROM PAST LIMITATIONS AND SET MYSELF FREE.

LIMITLESS SUCCESS COMES TO ME RIGHT NOW.

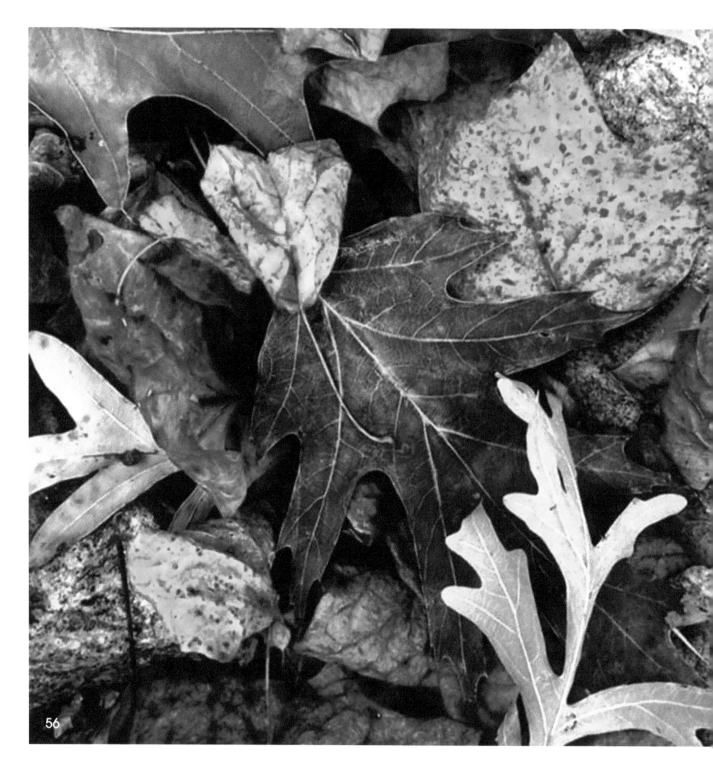

FALL LEAVES
SYMBOLIZE
CHANGE

It is the world's very nature to be constantly changing. Trees, an intrinsic part of this change, know to let go and shed their leaves in the most resplendent colors. They don't resist. They accept and graciously wait for their renewed life in the springtime. The beauty of fall leaves can remind us to ignite the change that comes from our universal connection within. Start with changing one thought, then another and another. Soon your observations, actions and expectations will begin to evolve and shape your life in the most rewarding ways.

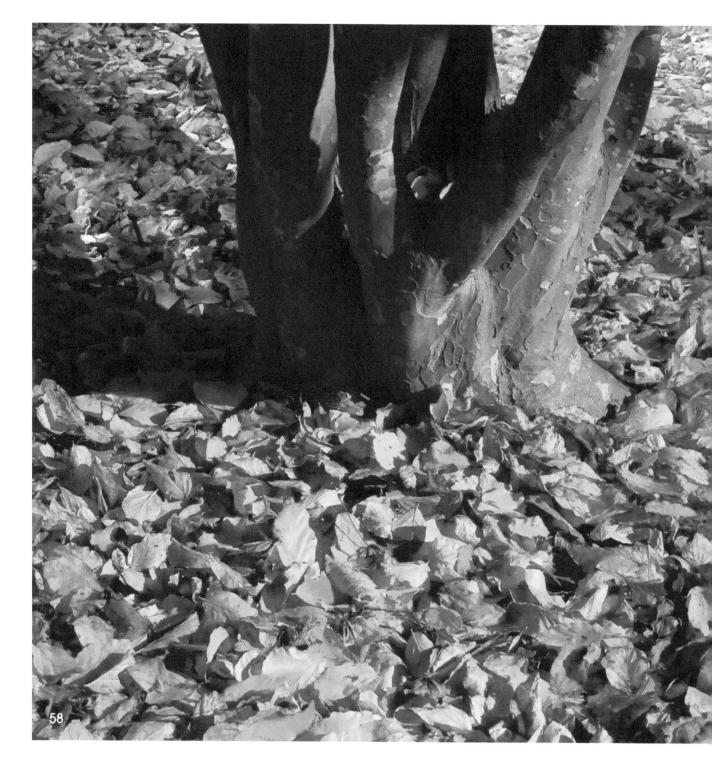

AFFIRMATIONS

I SHED THE PAST AS MY LIFE CHANGES PEACEFULLY.

CHANGE BRINGS ME NEW AND EXCITING OPPORTUNITIES.

I AM READY TO CHANGE MY LIFE FOR THE BETTER.

FALL LEAVES SHOW ME HOW BEAUTIFUL IT IS TO LET GO.

I AM SAFE TO START ALL OVER AGAIN.

I TRUST THAT EVERYTHING IS FALLING INTO PLACE.

I WELCOME TRANSITION WITH ENTHUSIASM.

I EMBRACE CHANGE FROM THIS MOMENT ON.

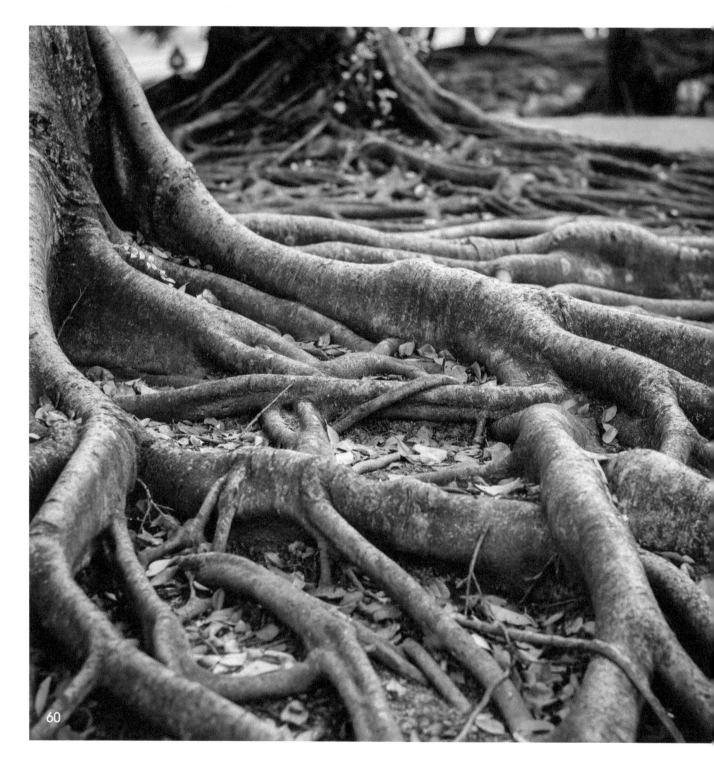

ROOTS
REPRESENT
CONNECTION

Everyone has a root. An origin that connects us to our place in this symbiotic universe. As humans, our deep roots anchor us and remind us where we come from. Your emotional, spiritual and intellectual sustenance all come from a connection with your family and friends and a strong awareness of your ancestors. Call upon your loved ones, past or present. Talk to them. Listen to them. They are already part of you and ready to provide the guidance that you may need right now.

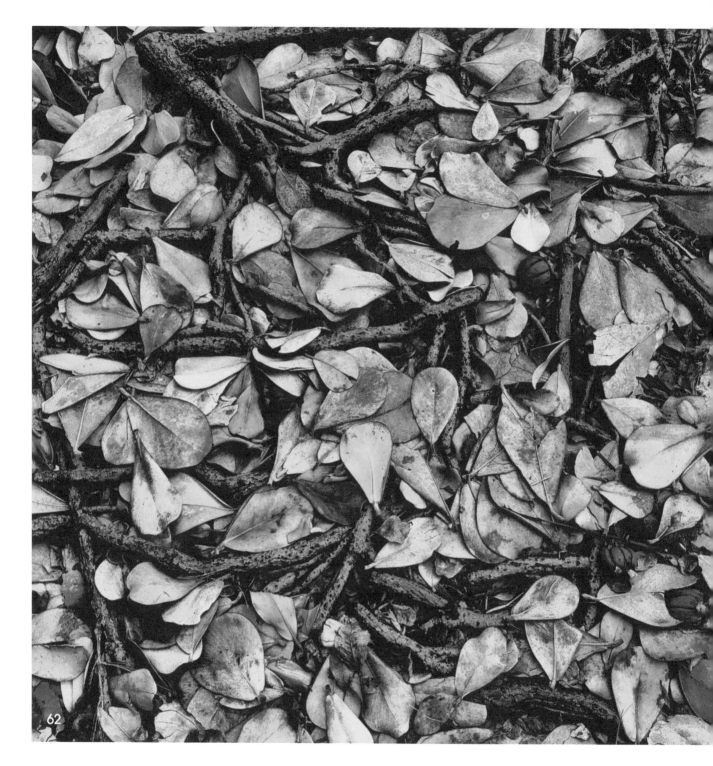

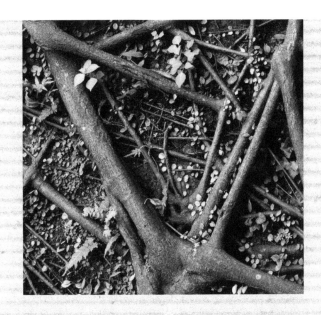

AFFIRMATIONS

I AM CONNECTED TO THE KNOWN AND UNKNOWN.

I AM CONNECTED TO THE ABUNDANCE OF THE UNIVERSE.

I AM IN CONSTANT CONNECTION WITH SUPPORTIVE FAMILY AND FRIENDS.

I AM CONNECTED TO WHERE I CAME FROM.

I AM ROOTED AND GROUNDED.

I AM CONNECTED AND HARMONIOUS WITH LIFE.

I AM CONNECTED TO WHO I AM NOW MORE THAN EVER.

MY HEART'S DESIRES ARE NOW TAKING ROOT.

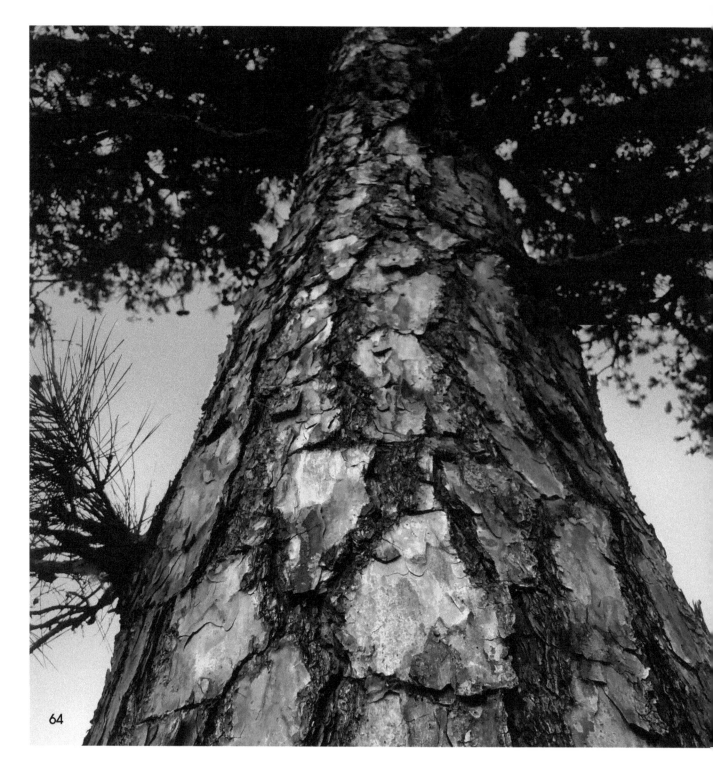

BARK
SYMBOLIZES
PROTECTION

Like trees, we renew from the inside out. Bark is the outer shield of a tree that protects its inner core by deflecting negative influences. It is easy to get drained from the complexities and challenges of the world today, and like the tree, you may need to create a protective shield that gives you time to recharge. If there is an area of your life that needs protection from harm or contains obstacles that make you feel stressed, unmotivated, angry or depressed, take a moment to build up your inner strength. Armour yourself, and no one will be able to take your power away.

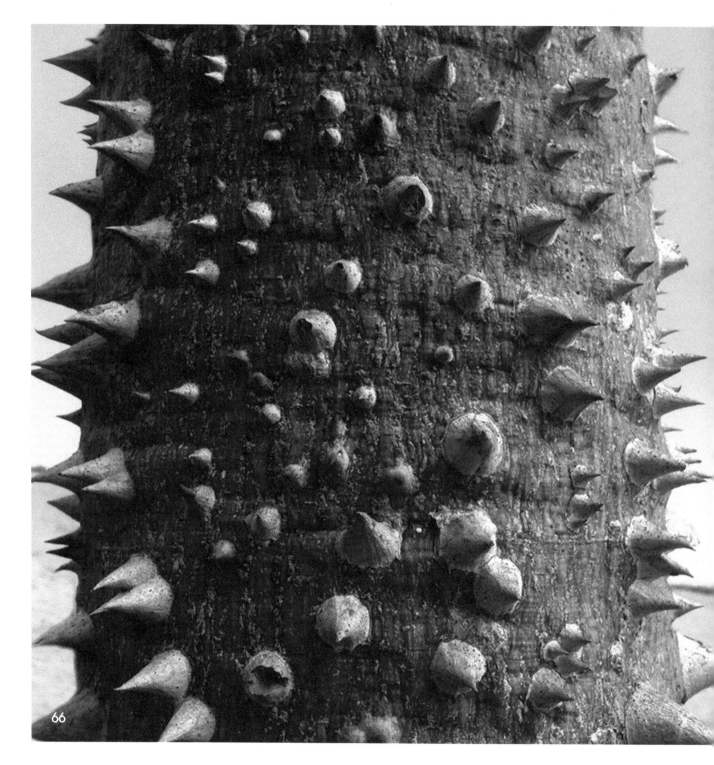

AFFIRMATIONS

I AM DIVINELY PROTECTED.

I AM SAFE AND STRONG ENOUGH TO VENTURE OUT.

I FEEL SAFE AND SECURE TO EXPRESS MYSELF OPENLY.

MY INVESTMENTS ARE SECURE.

ADAPTABILITY IS THE BEST PROTECTION IN ANY SITUATION.

PROTECTIVE FORCES WATCH OVER ME.

MY PROSPERITY IS GUARANTEED.

I PROTECT MYSELF FROM NEGATIVE ENERGY.

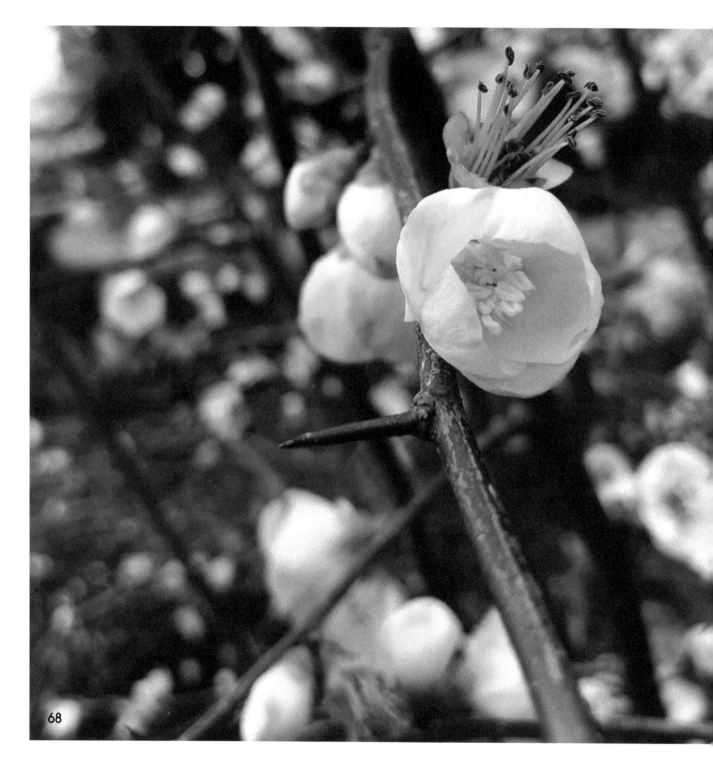

BLOSSOMS
EMBODY
RENEWAL

Spring is a time of renewal and rebirth. It's a time when blossoms colorfully leap out to remind us of the positive efforts we've planted. It's a time that your thoughts and actions can shape your future. Blossoms can remind you to take action to restore your energy, make new plans, start creative projects or do something wonderfully different. Their beauty awakens and blooms into new life, appearing in you as a renewed sense of joy, hope and optimism.

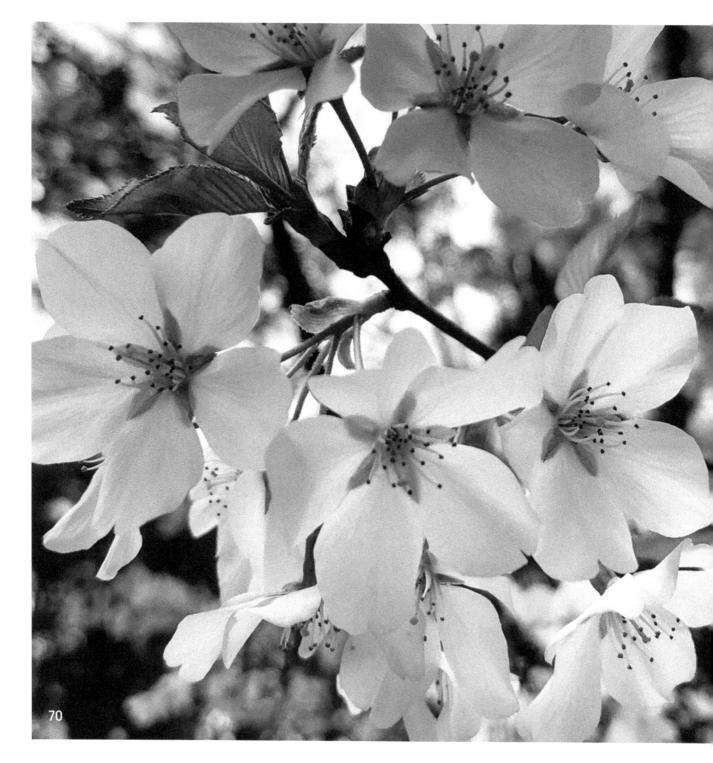

AFFIRMATIONS

I AM READY TO RELEASE, RESTORE AND RENEW.

MY RENEWED INNER STRENGTH WILL GET ME THROUGH THIS.

I HAVE A RENEWED SENSE OF WHERE I AM IN LIFE.

IT'S TIME TO START SOMETHING NEW.

MY BODY RENEWS AND REJUVENATES TOWARD PERFECT HEALTH.

I AM OPEN TO ADVENTUROUS NEW BEGINNINGS.

I RENEW MY COMMITMENTS TO MY FRIENDS AND FAMILY.

I HAVE A NEW ATTITUDE AS I MOVE FORWARD.

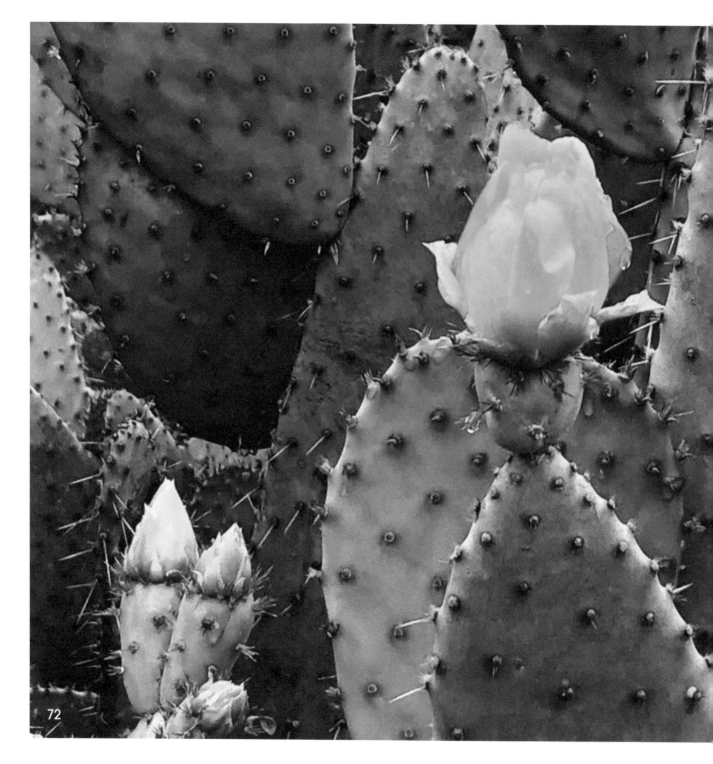

CACTI
REPRESENT
ENDURANCE

Cacti thrive with limited resources in the most adverse conditions. A desert cactus blooms in the midst of scorching temperatures and drought. Its prickly exterior stores water and energy, creating a reserve when it needs to adapt and endure. A cactus can exemplify the message to dig deep to get through the challenges around you, ultimately knowing that you will be okay. Firmly accept that no matter how tough your situation might be, you can turn it into an advantage and overcome.

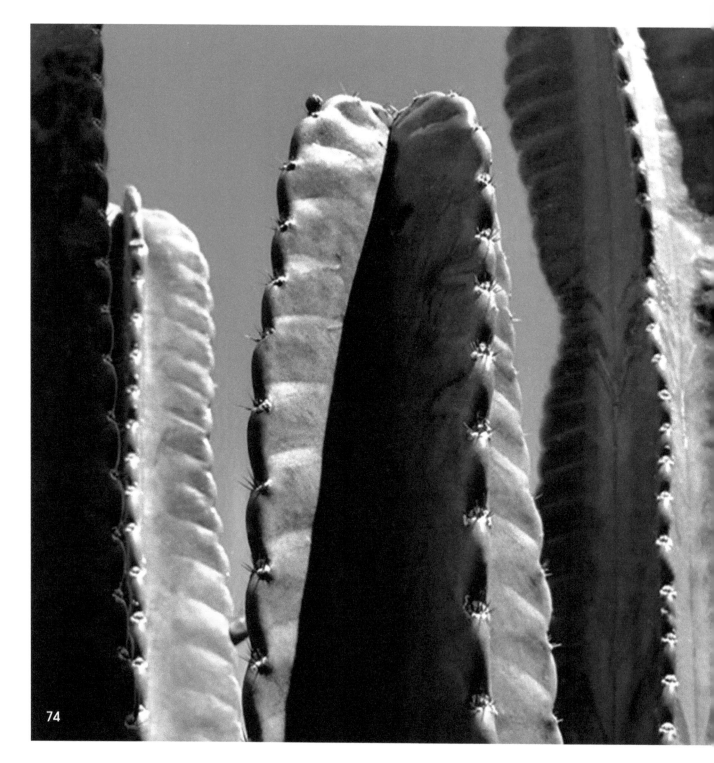

AFFIRMATIONS

I AM UNSTOPPABLE.

I HAVE THE TOUGHNESS TO SURVIVE AND OVERCOME CHALLENGES.

I FINISH WHAT I START WITH EASE, JOY AND CONVICTION.

I HAVE THE ENDURANCE TO FACE THE CHALLENGES BEFORE ME.

I ADAPT PEACEFULLY AND PROACTIVELY TO THE CHANGES AROUND ME.

I DO NOT ALLOW OTHERS TO DRAIN MY ENERGY.

I HAVE THE POWER IN ME TO STAND THE COURSE.

I ALWAYS FIND SUCCESSFUL SOLUTIONS.

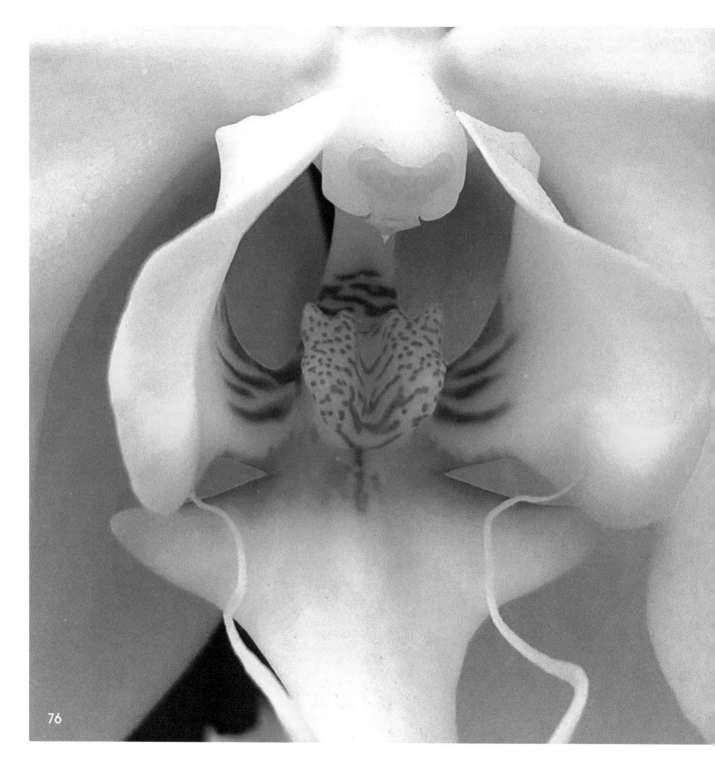

ORCHIDS
SYMBOLIZE
GRACE

Grace is the embodiment of simple elegance, truth and goodness. It's the ability to encourage togetherness and evoke unconditional love and forgiveness. Orchids are among the most exquisite flowers. Awareness of their fragrance, color and delicate contours can calmly bring you to a state of grace. It's here where you can begin to reframe irritations, disappointments and stubborn grudges into opportunities for mercy and acceptance. You then become an example of change by spreading positive energy to others.

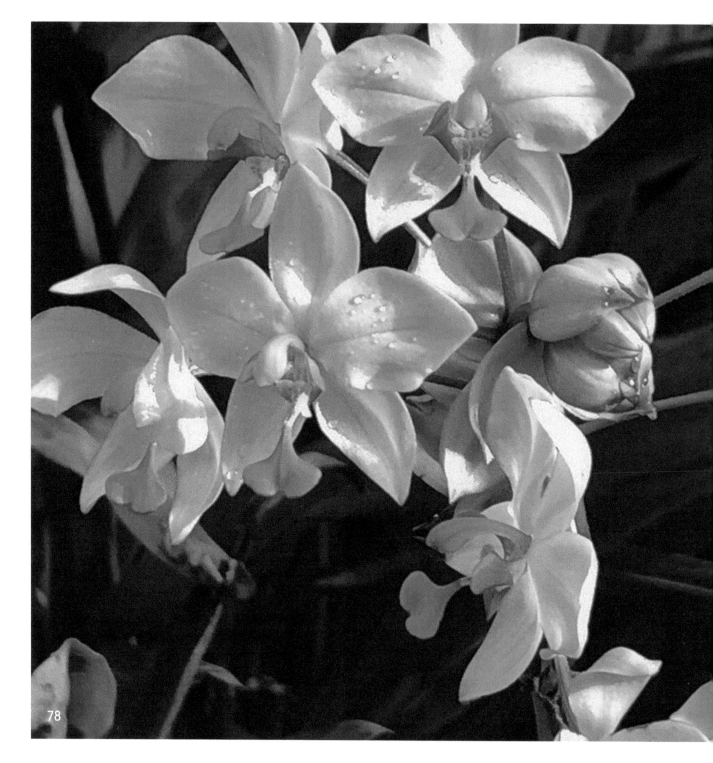

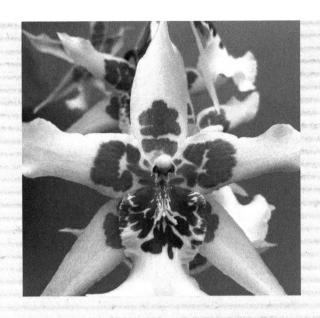

AFFIRMATIONS

I PEACEFULLY MAKE THE BEST OF ALL CIRCUMSTANCES.

I AM FORGIVING, LOVING AND KIND TO MYSELF AND OTHERS.

BY GRACE ALONE, I GROW AND PROSPER.

MY RHYTHM IN LIFE STAYS HELPFUL, GENEROUS AND SUPPORTIVE.

UNCONDITIONAL SHARING MAKES ME FEEL WONDERFUL.

I SOFTEN MY WORDS TO BE KINDER.

MY LIFE FLOWS IN PEACE, GRACE AND CALMNESS.

I LIVE WITH LOVE, GRACE AND GRATITUDE.

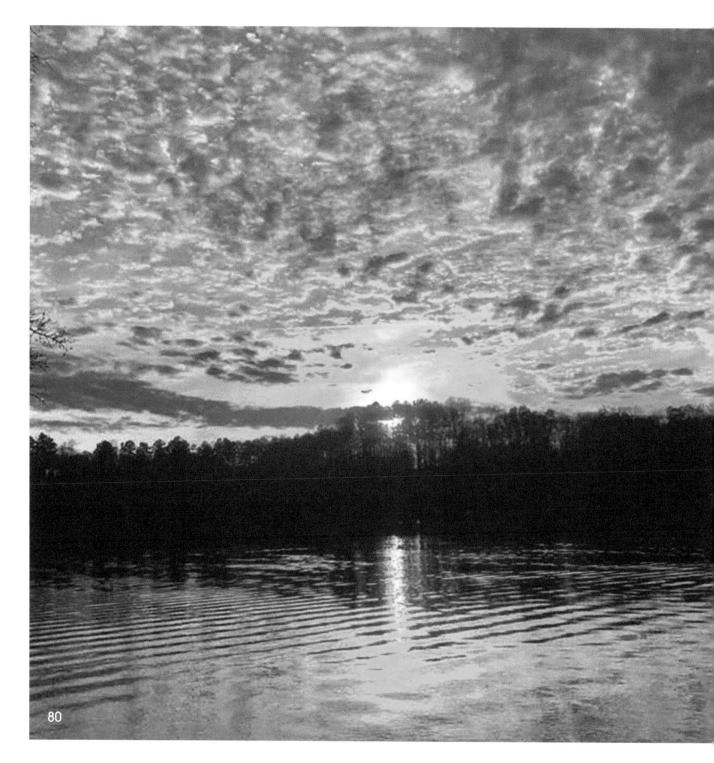

SUNSETS
REPRESENT
DETACHMENT

In many ways, Mother Nature's greatest masterpiece is a sunset. Sunsets can leave you speechless, as the warm colors bathe you and your surroundings. Watching a sunset can peacefully close out the day and relax the mind. It can free you from any sense of fear, anxiety and sadness, but it can also celebrate your joy, love and gratitude. Detachment has another spiritual function when it comes to manifesting your desires. Set your specific intentions. As the sun sets, release them to a higher power and detach. Take a break from trying too hard, thinking too much. Rest up, and notice when positive things start to happen.

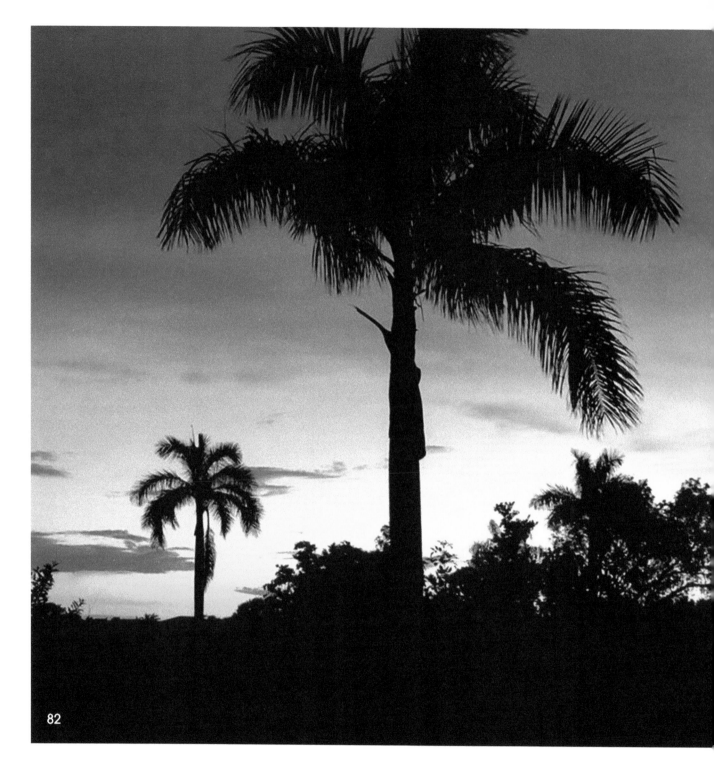

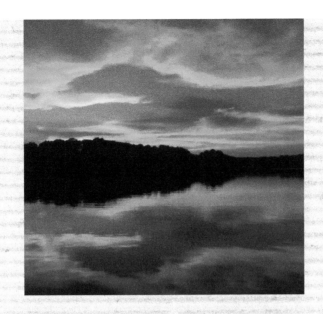

AFFIRMATIONS

I LET GO AND I AM FREE.

WHEN I DETACH FROM MY DESIRE, IT HAPPENS.

I PEACEFULLY RELEASE MY NEED FOR CONTROL.

I CLEAR MY MIND FOR TOMORROW'S MIRACLES.

MY PAST HAS SERVED ITS PURPOSE AND FUELS MY FUTURE.

I AM READY TO START A NEW CHAPTER IN MY LIFE.

I LET GO OF ALL ANGER, PAIN, FEAR AND JUDGMENT.

I NO LONGER WORRY WHAT OTHERS THINK.

If you liked this book, here are other titles by this author:

Nose Art by Lucas
Recent Work: Nose Smudges on Car Window

My dog Lucas creates. One day I noticed that his nose smudges on my car window looked like art, especially when the sunlight was shining through at just the right angle. I photographed them at different times and places and soon an art exhibit was born. You are cordially invited to Lucas's first one-dog show—in a book!

Luv, Lucas
Life Learnings from a Four-legged Friend

There are lots of lessons we can learn from dogs. For starters, dogs live in the moment, are always ready for an adventure and accept themselves just the way they are. This book shares the adventures of Lucas growing up through colorful illustrations and delivers wholesome insights we can all live by.

Lucas Luvs Silence
The Perfect Moments of an Adventurous Deaf Dog

Disabilities are often perceived as limitations and rarely as opportunities to adapt and engage in the hundreds of other dimensions of a person's life, or in this case, a dog's life. This book challenges and reframes that perception through the adventures of a deaf dog who embraces who he is, adapts when he needs to and moves on to living his happy and complete life.

Lucas Luvs Animals from A to Z

There are so many animals that love and nurture other animals. You've seen them on social media: the dog who nurses kittens, the duck who feeds the koi fish, the cat that cuddles with ducklings. My dog Lucas is one of those animals. He has a genuine fondness for, and fascination with, all his animal friends. In this book, Lucas takes us on a tour of the amazing animal world from A to Z. I hope you will find delight in learning with Lucas that our weird, wild and wonderful animals are truly nature's greatest gift.

CPSIA information can be obtained
at www.ICGtesting.com
Printed in the USA
BVHW021054151221
621588BV00005B/79